Antique Fruit Prints for Adult Colorists
Volume II

30 Antique fruit print designs from the late 1700's to the early 1900's.
Interestingly and sadly, you may observe that many of the varieties listed in the index and displayed on the pages are now extinct.

Copyright 2016 by Carol Mennig
All Rights Reserved.
ISBN: 1539327582
ISBN-13: 978-1539327585

Index

Assorted Fruit.....Page 3
Banner Grapes.....Page 5
Bartlett Pear 1.....Page 7
Bartlett Pear 2.....Page 9
Bennett Apple......Page 11
Bountful Harvest......Page 13
Brittlewood & Stoddard Plums.....Page 15
Bryant Apple.....Page 17
Carson Apple.....Page 19
Chinese Jujube.....Page 21
Coffman Apple.....Page 23
Colman Citrange.....Page 25
Ensee Apple.....Page 27
Eulalia Loquat.....Page 29
Hiley Peach.....Page 31
Ingram Apple.....Page 33
King Orange.....Page 35
Morton Citrange.....Page 37
Panariti Grapes.....Page 39
Peters Mango.....Page 41
Randolph Apple.....Page 43
Savage Citrange.....Page 45
Shiawassee Apple.....Page 47
Terry Apple.....Page 49
Thomson Orange.....Page 51
Virginia Beauty Apple.....Page 53
Washington Plum.....Page 55
Wheeler Peach.....Page 57
William Apple.....Page 59
Zengi.....Page 61

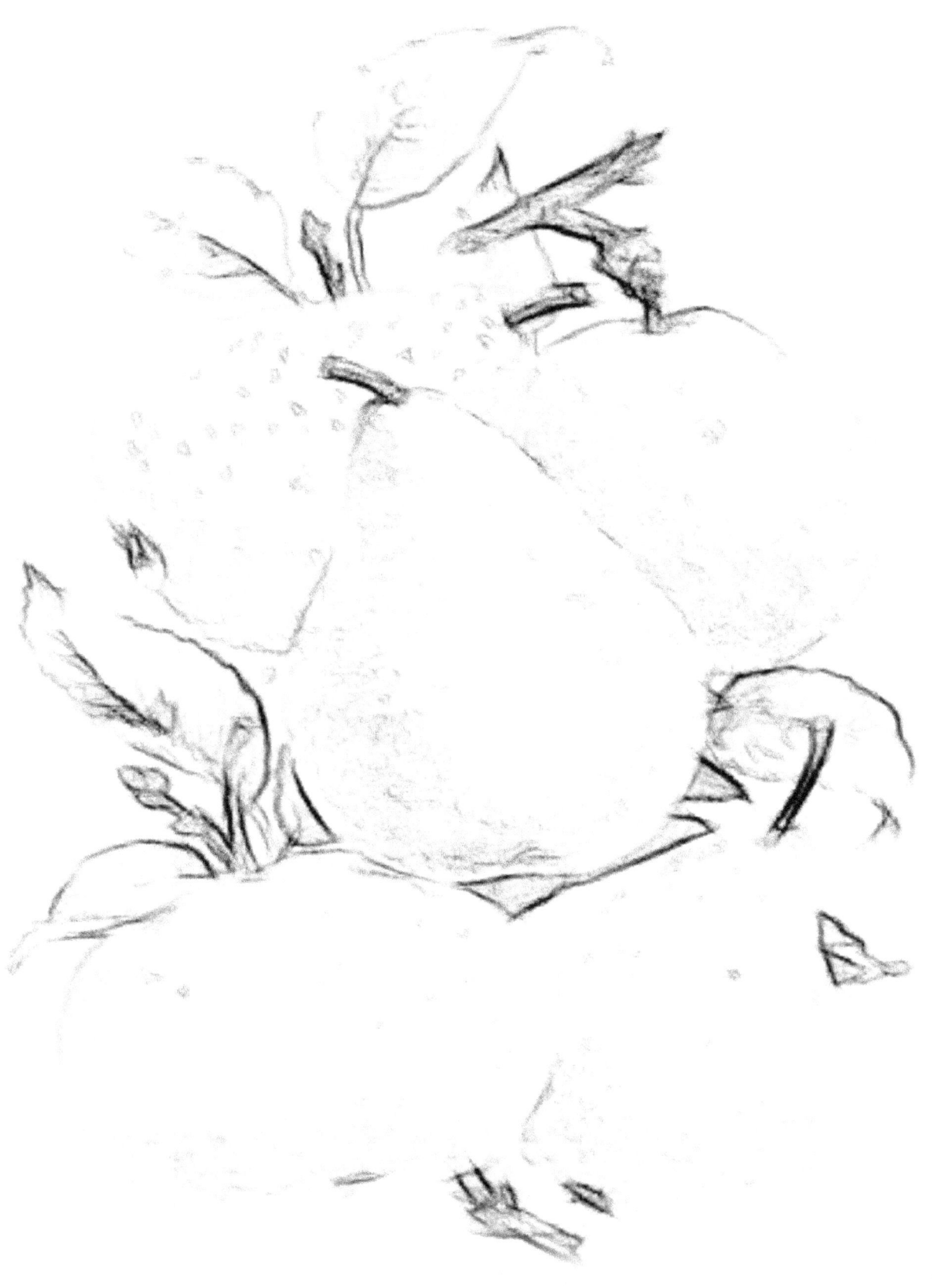

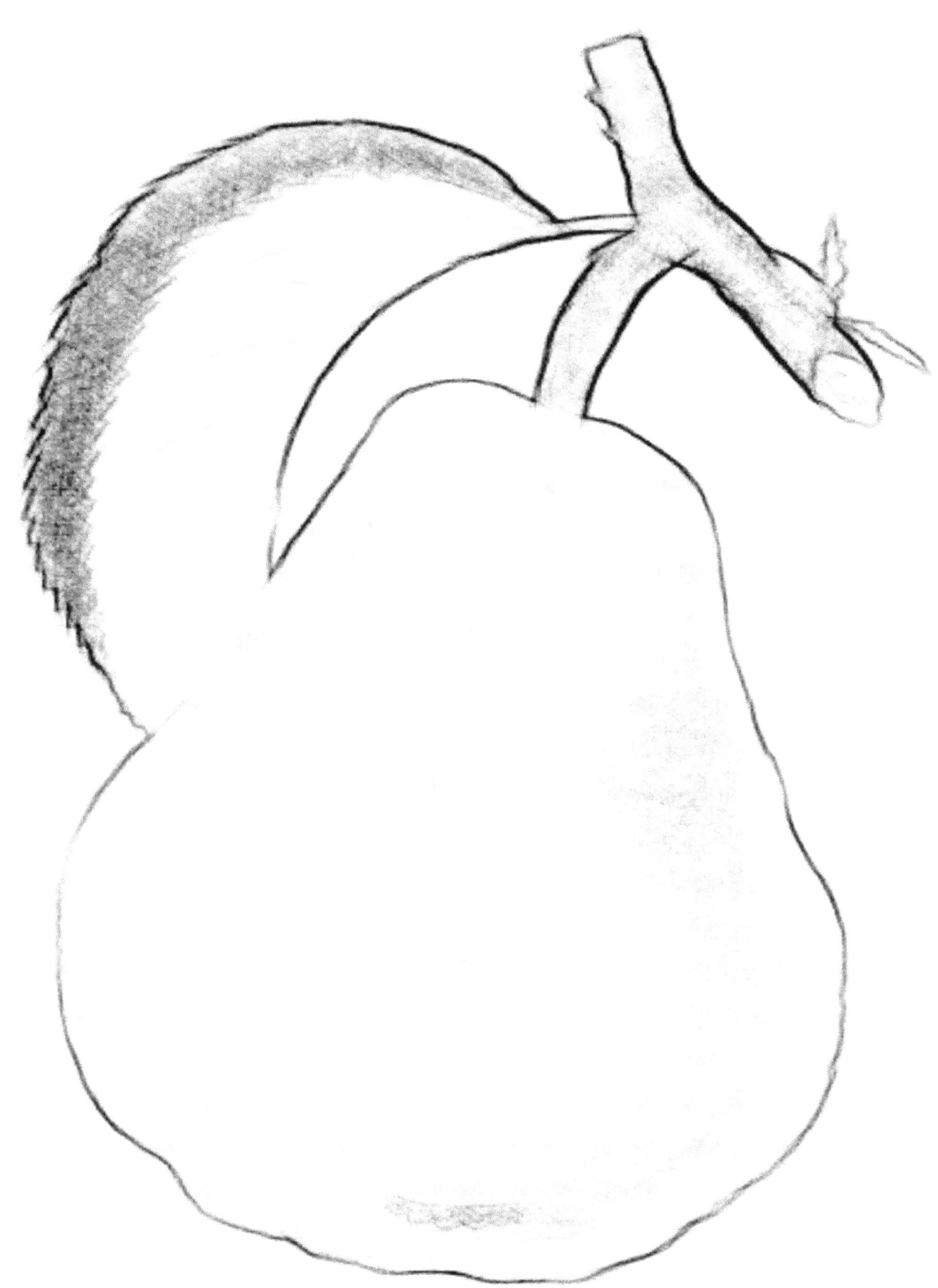

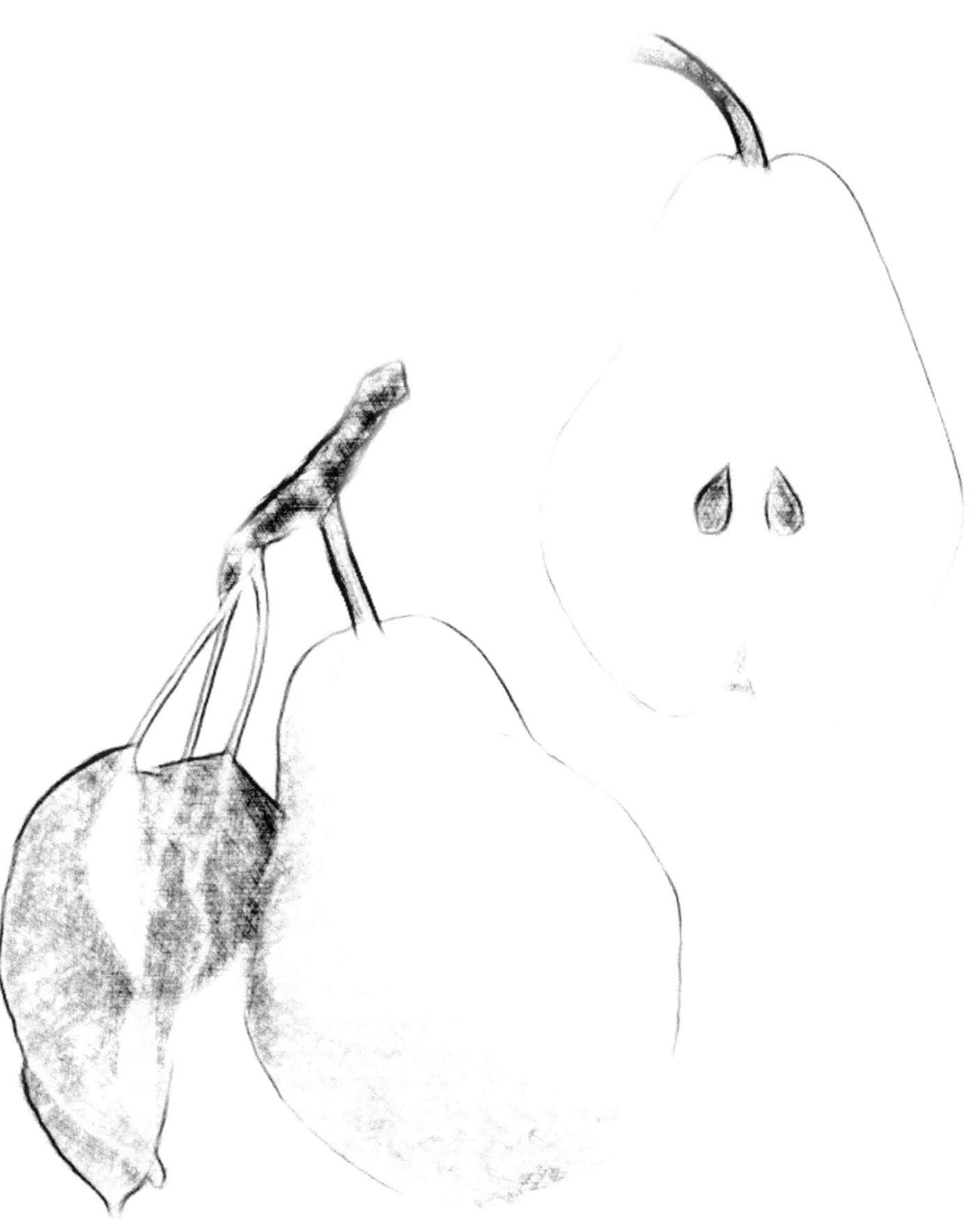

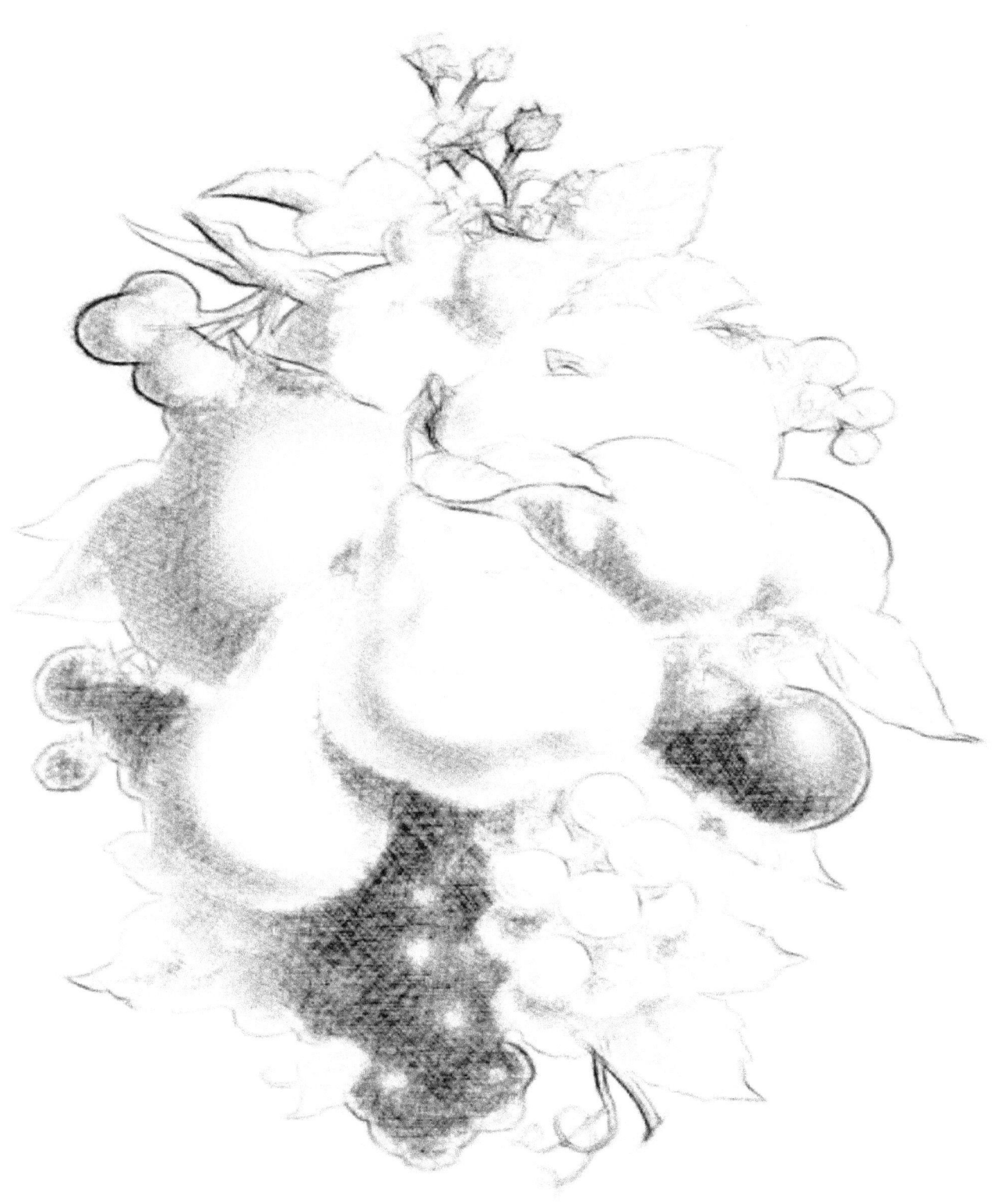

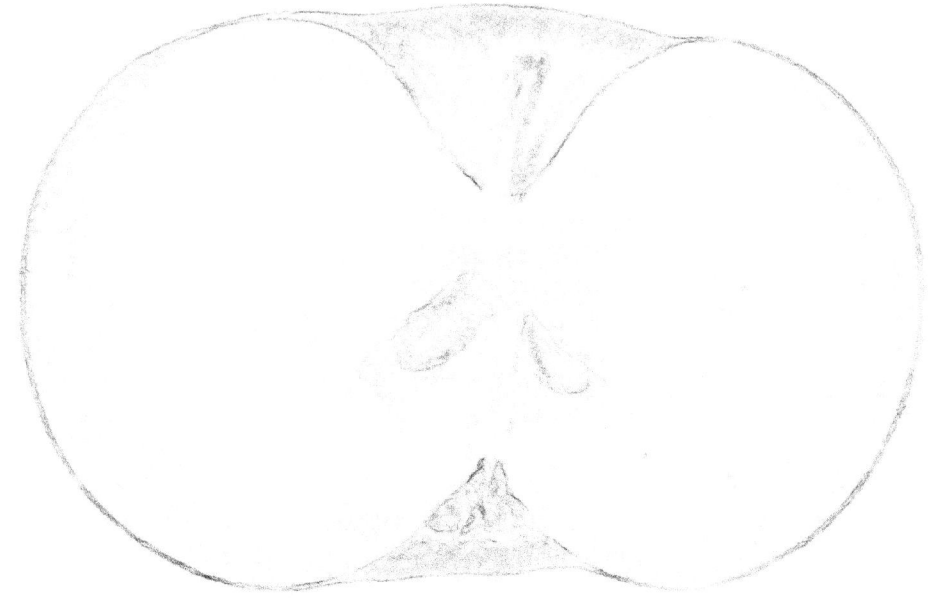

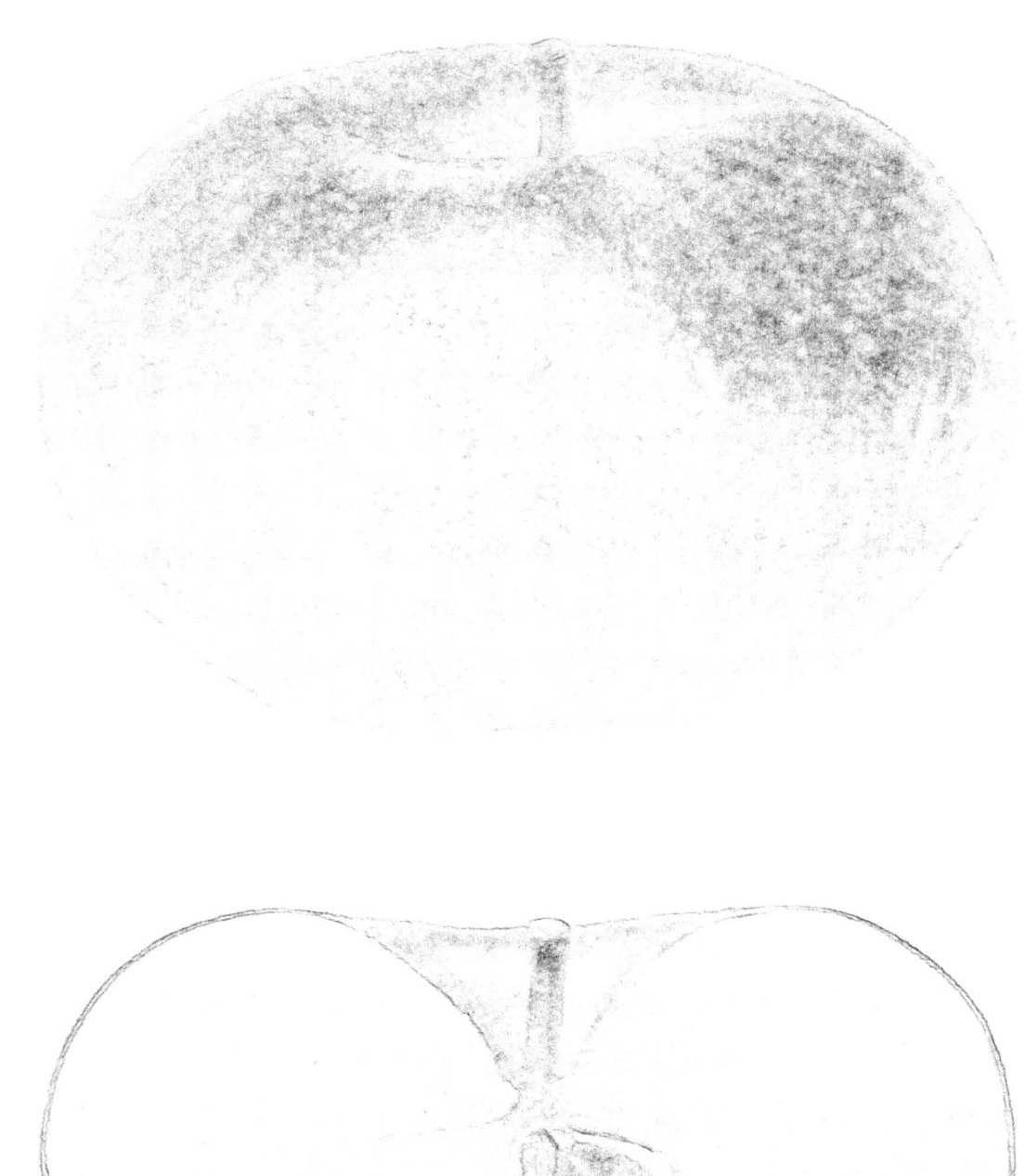

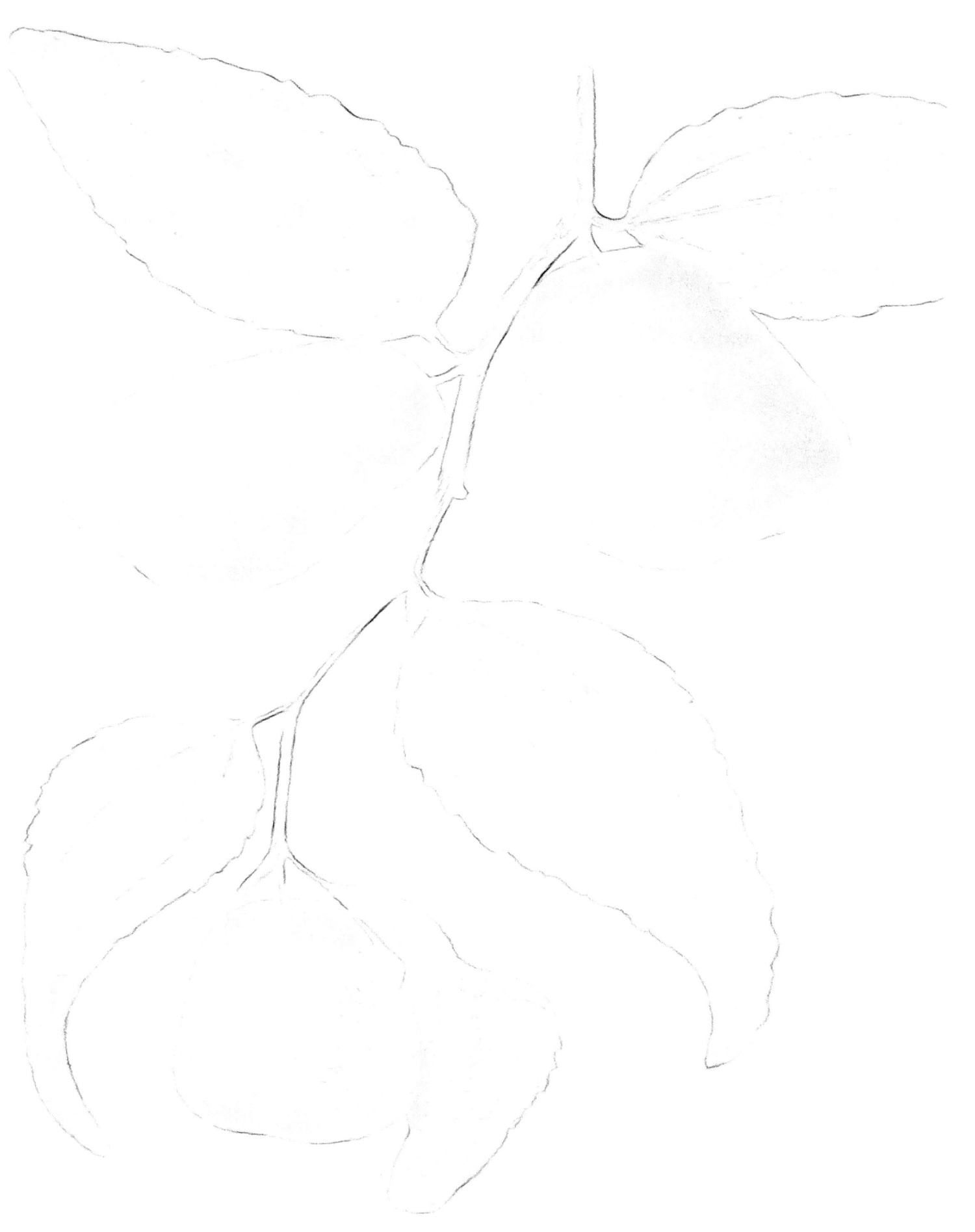

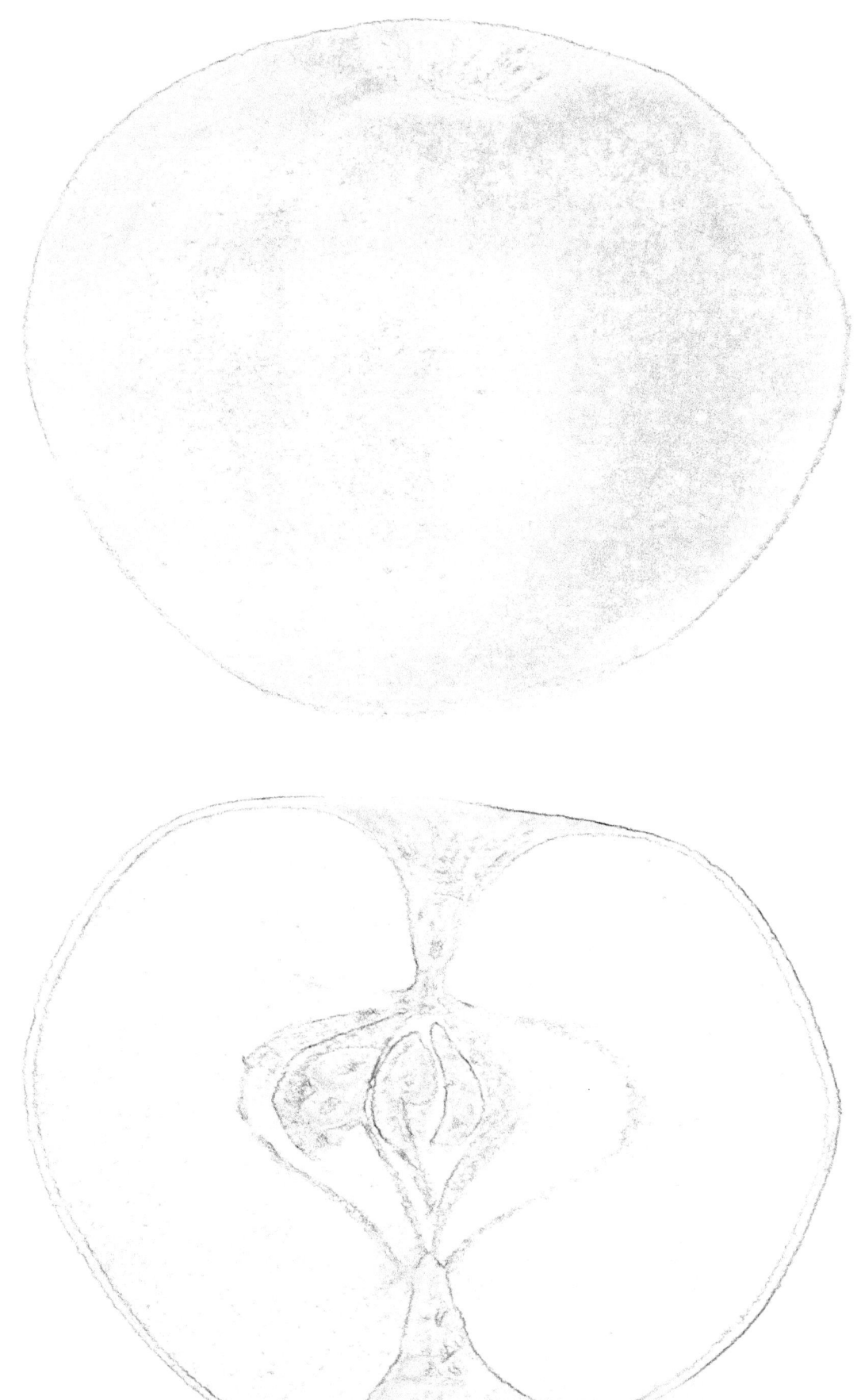

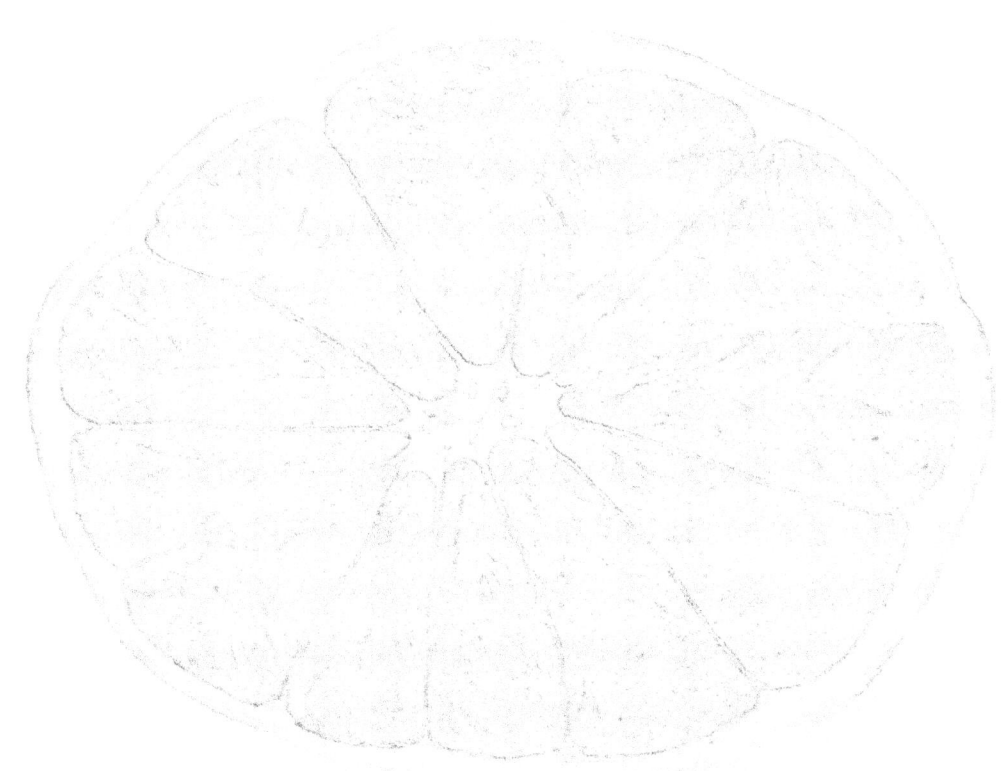

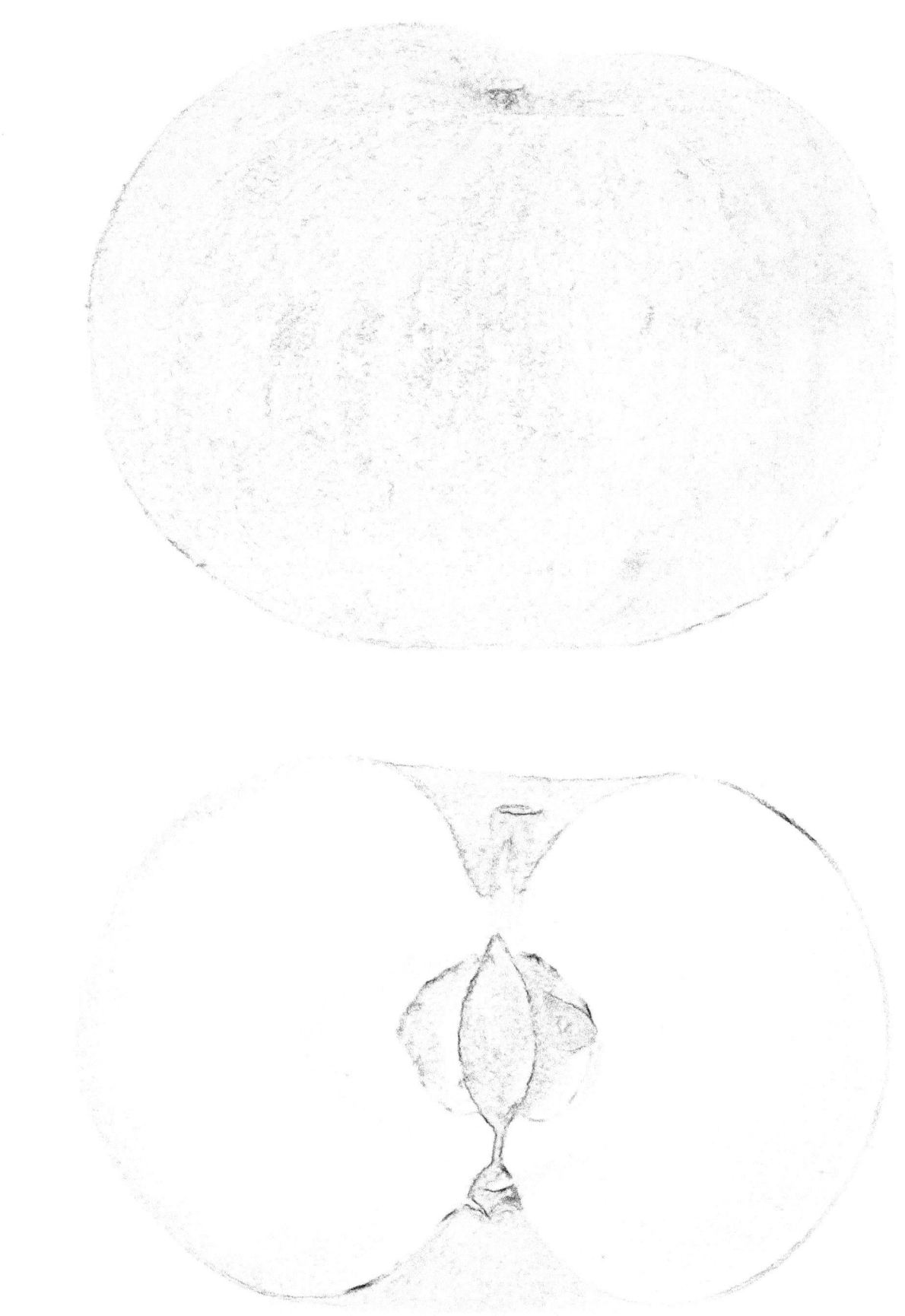

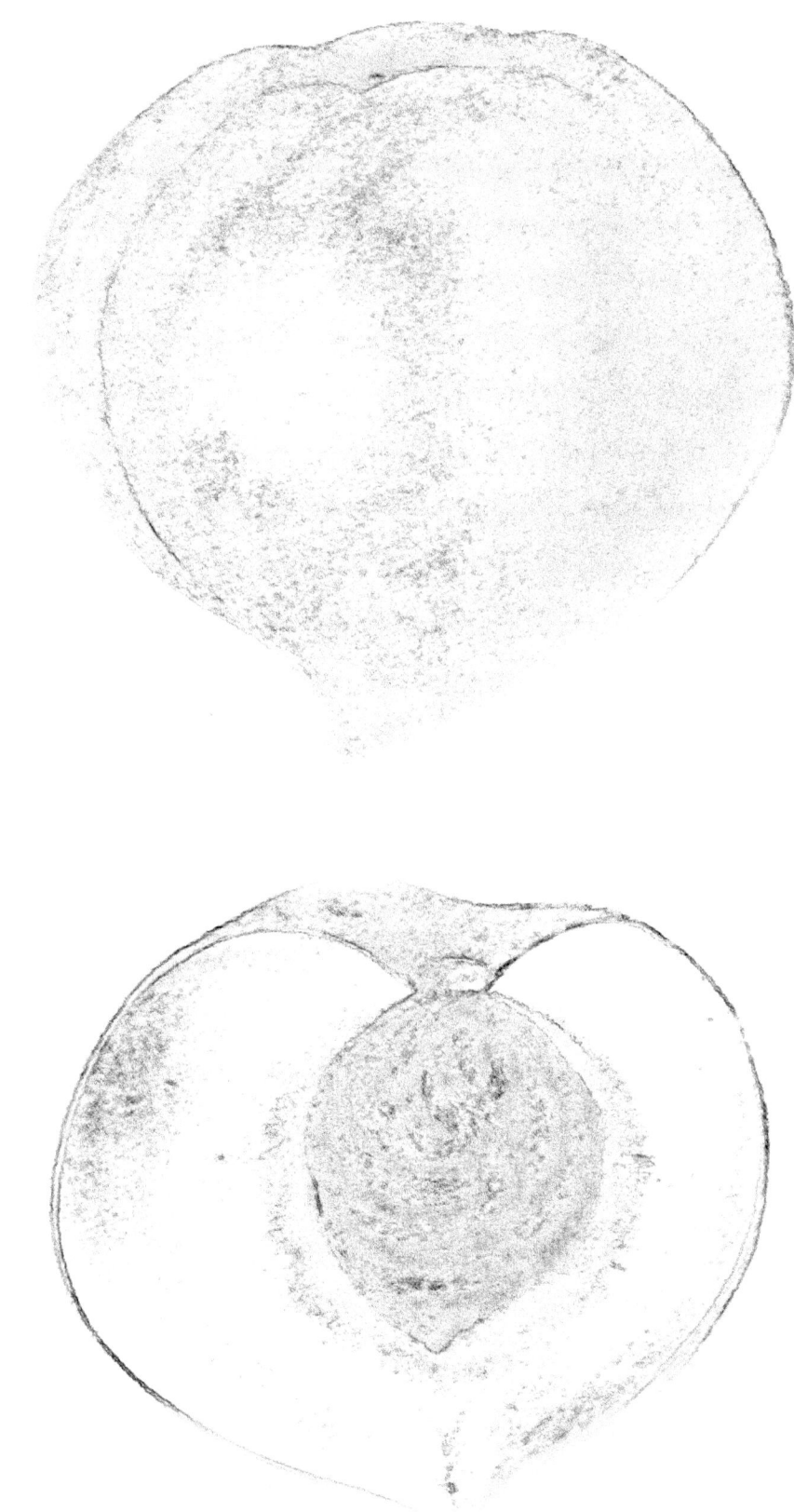

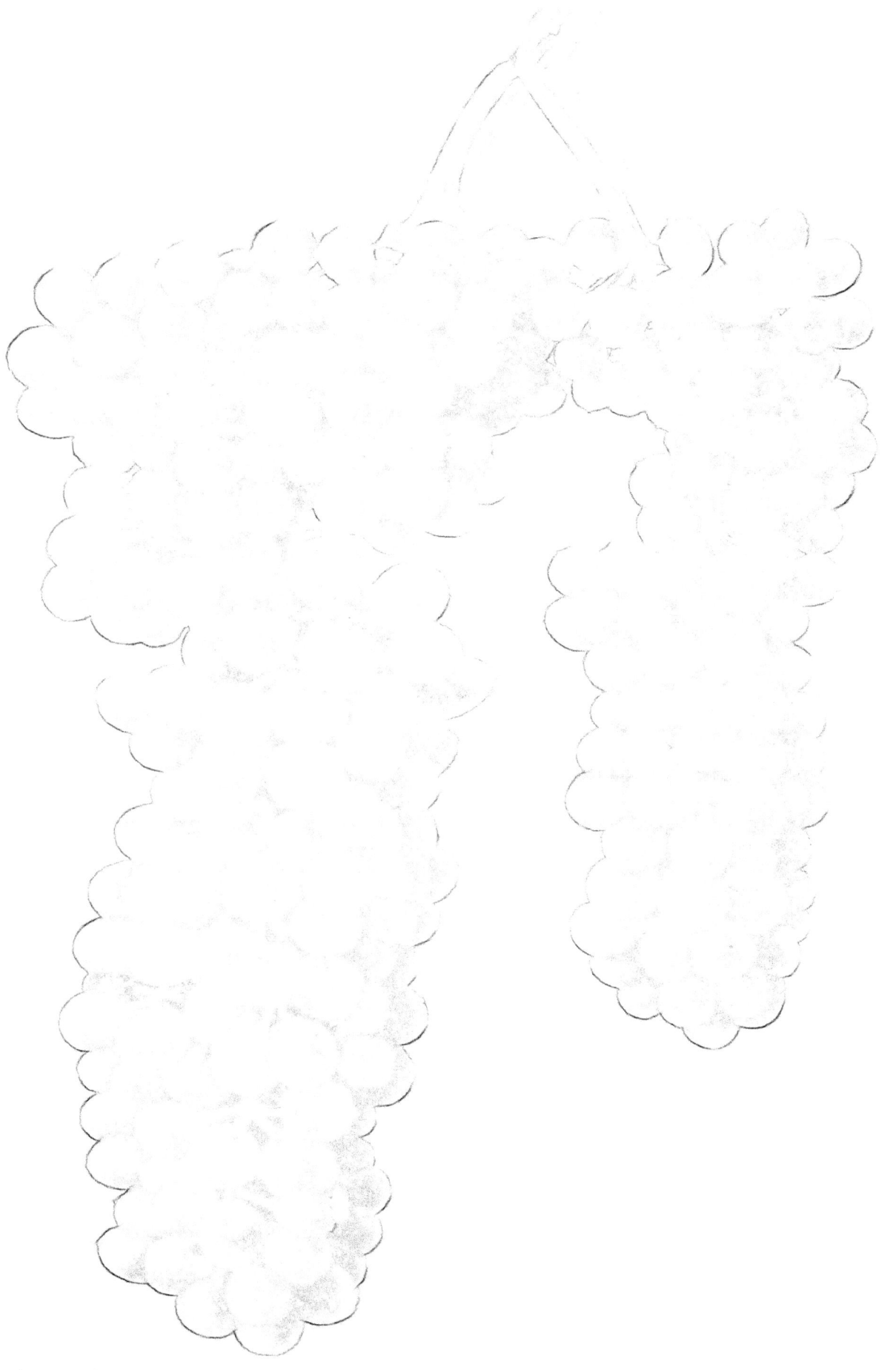

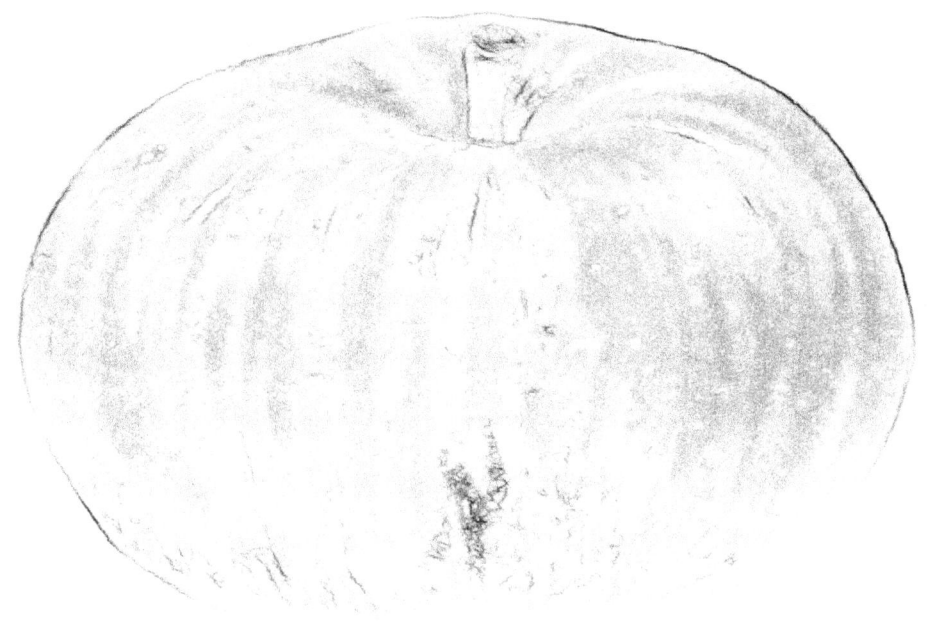

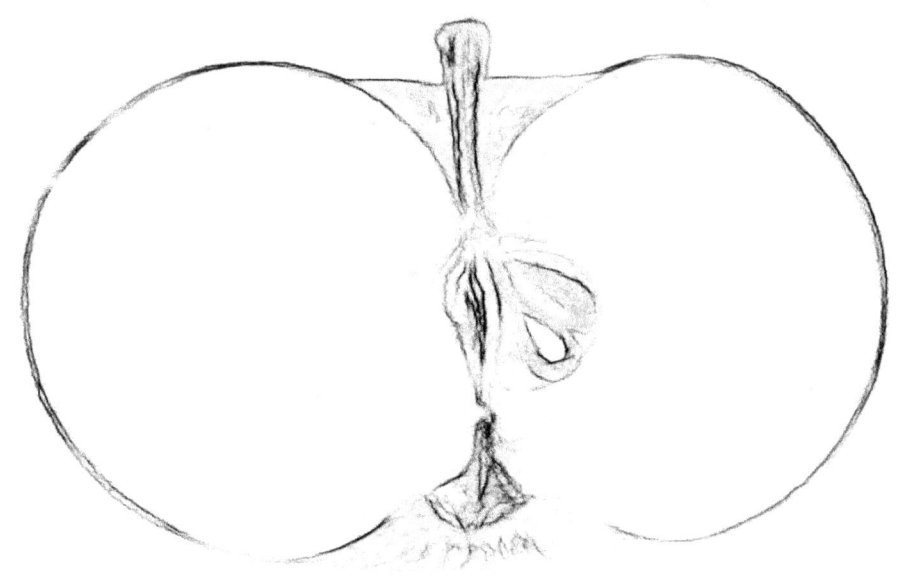

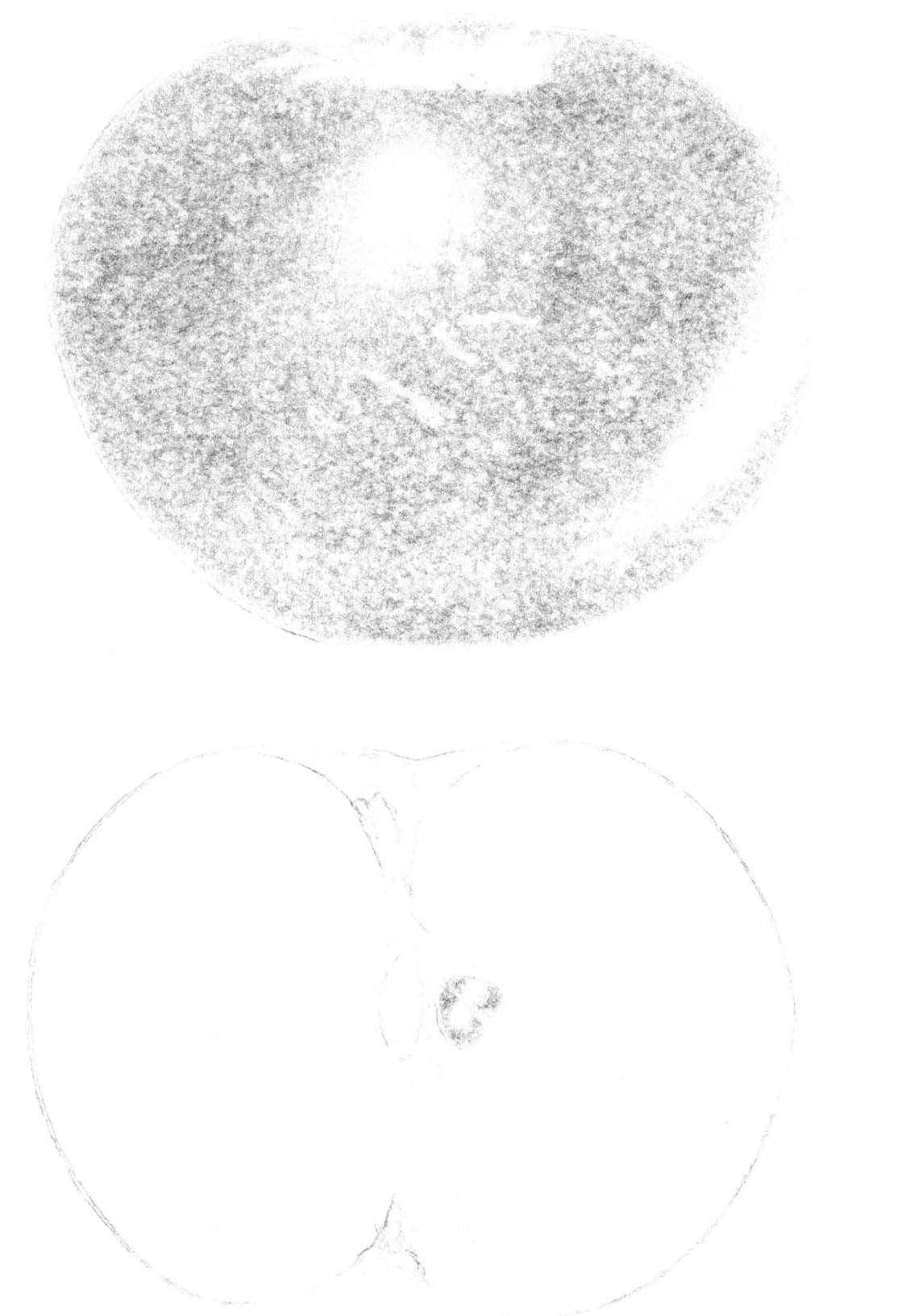

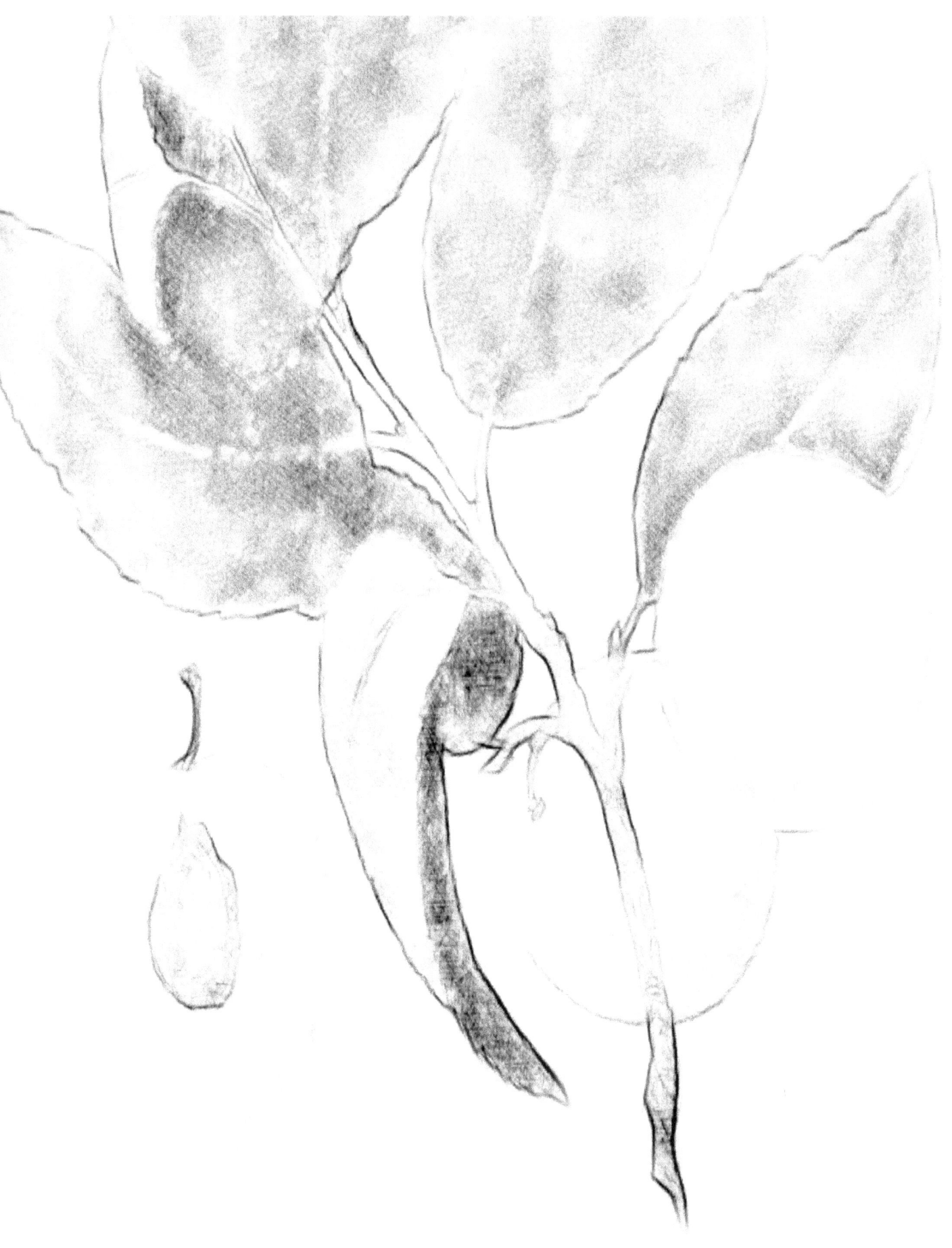

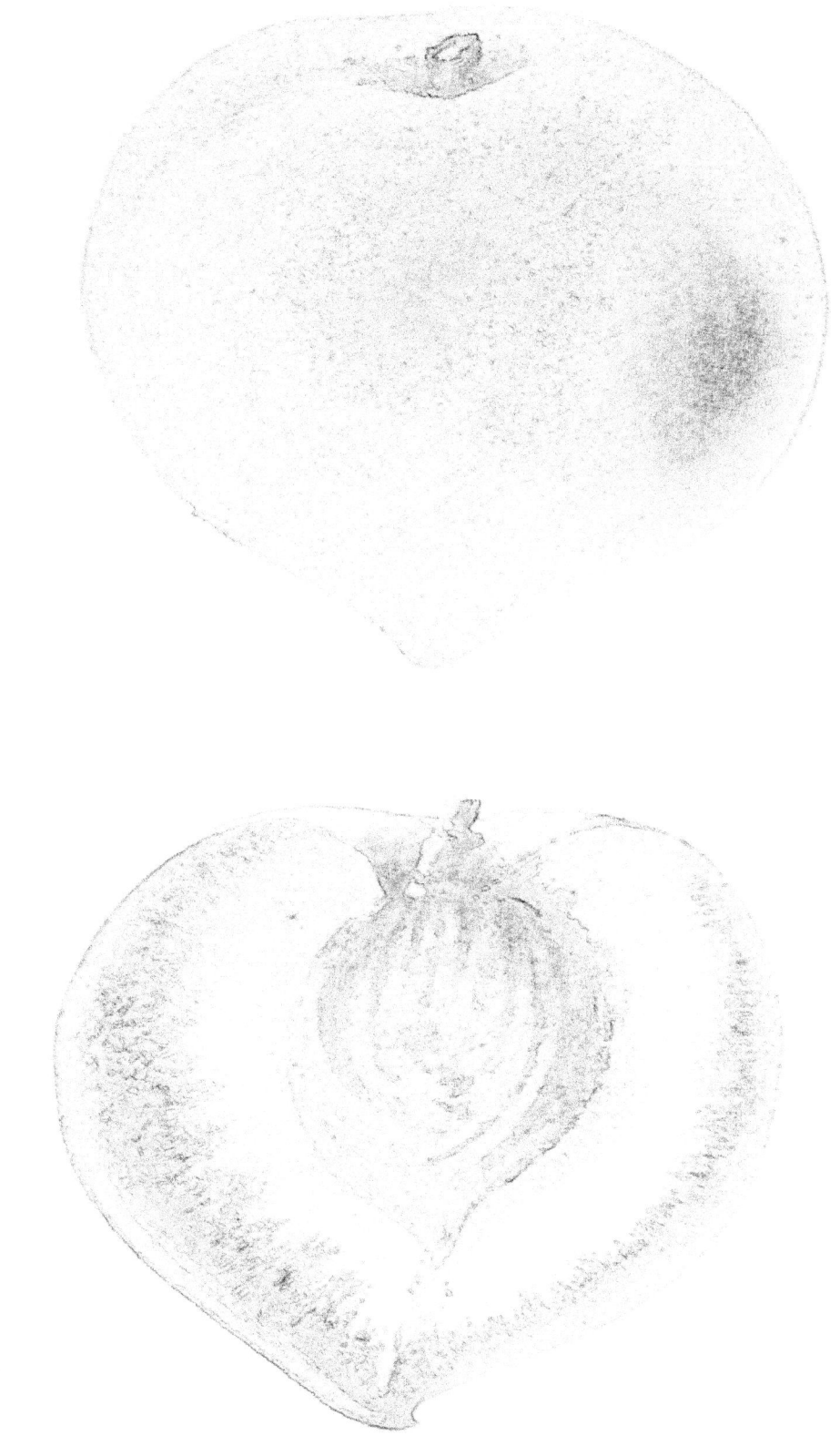

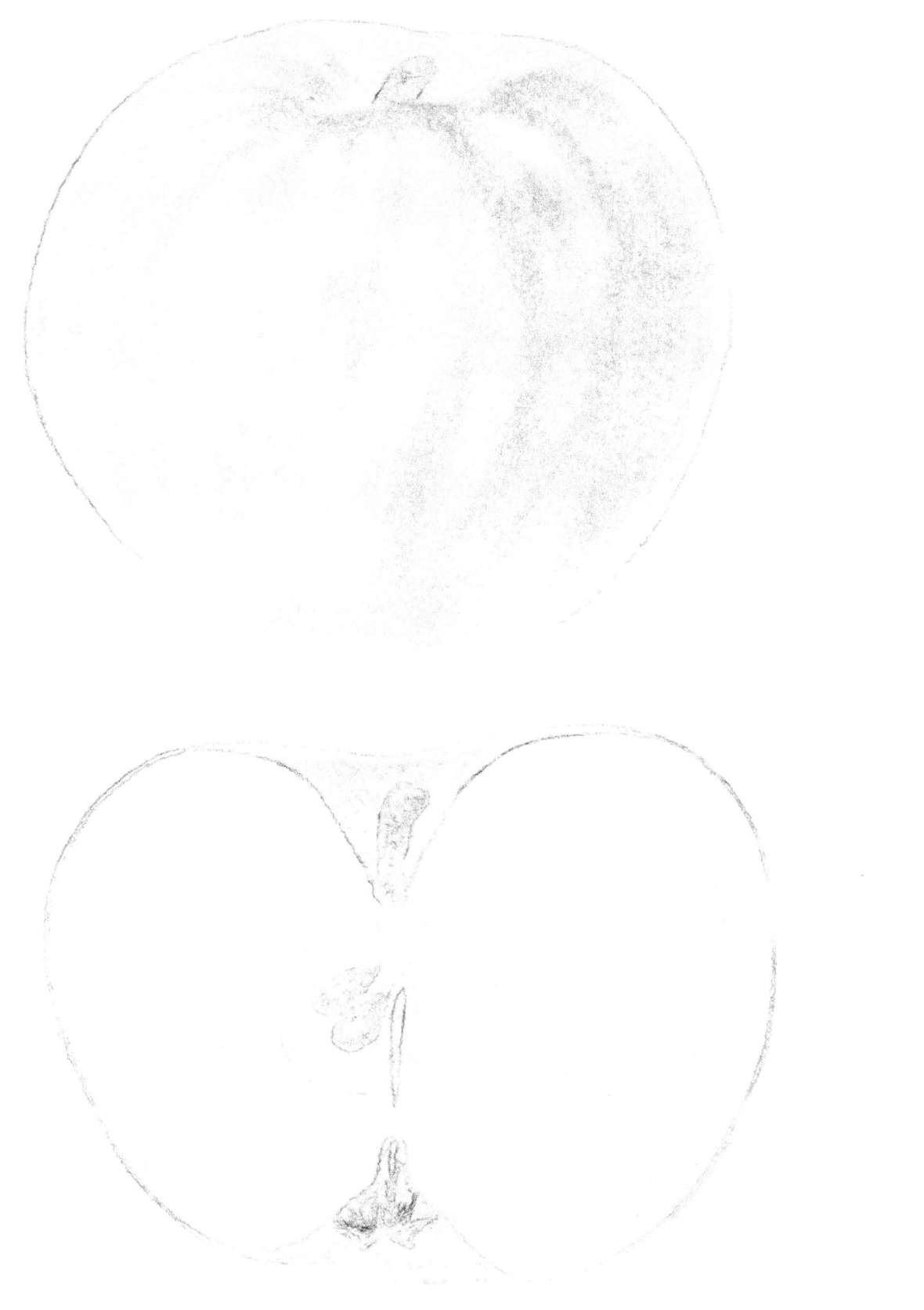

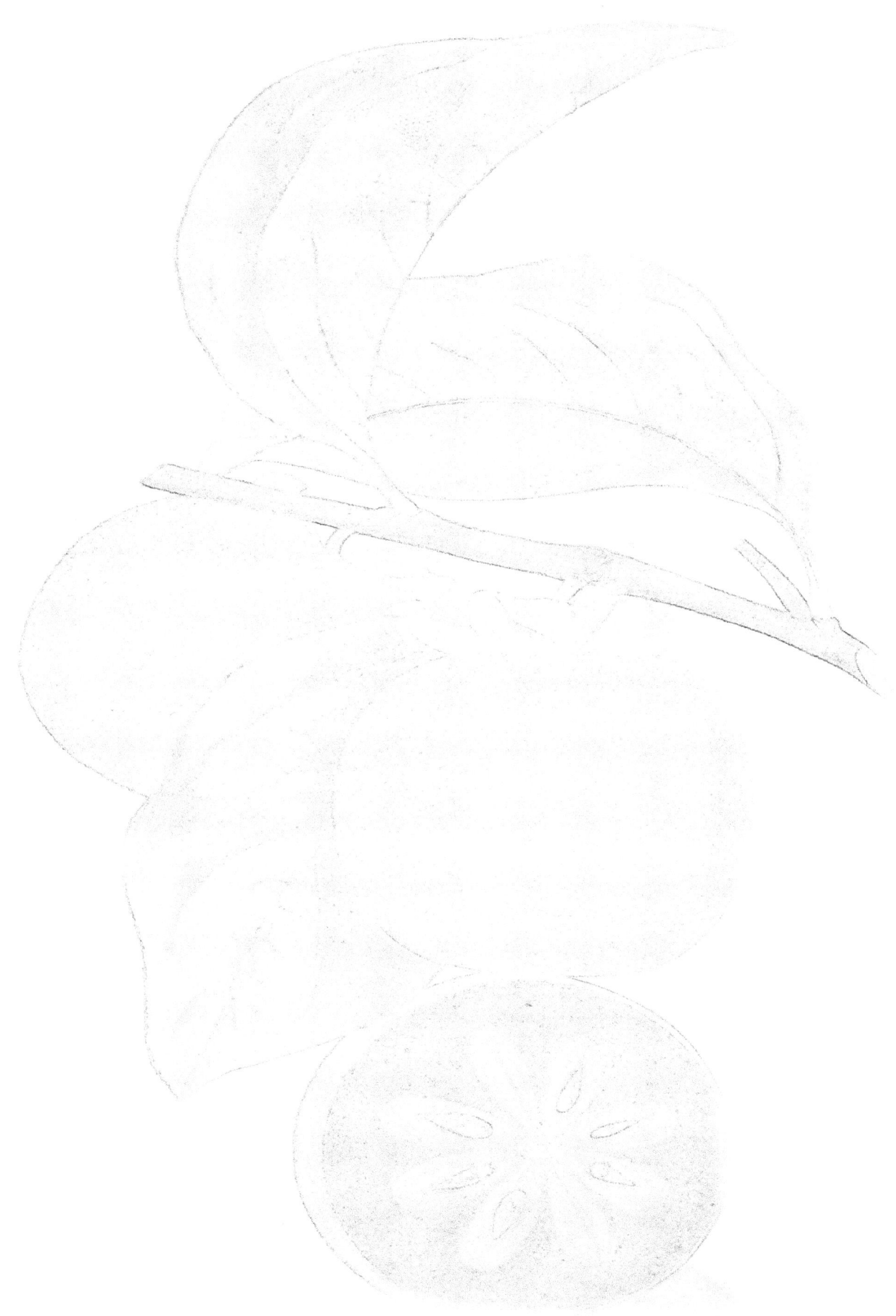

www.ingramcontent.com/pod-product-compliance
Lightning Source LLC
Chambersburg PA
CBHW080546190526
45169CB00007B/2662